Otherworldly Characters
For colouring

By Laz

Copyright © 2016 Lazaros Kalogirou

All rights reserved.

ISBN: 1539312712

ISBN-13: 978-1539312710

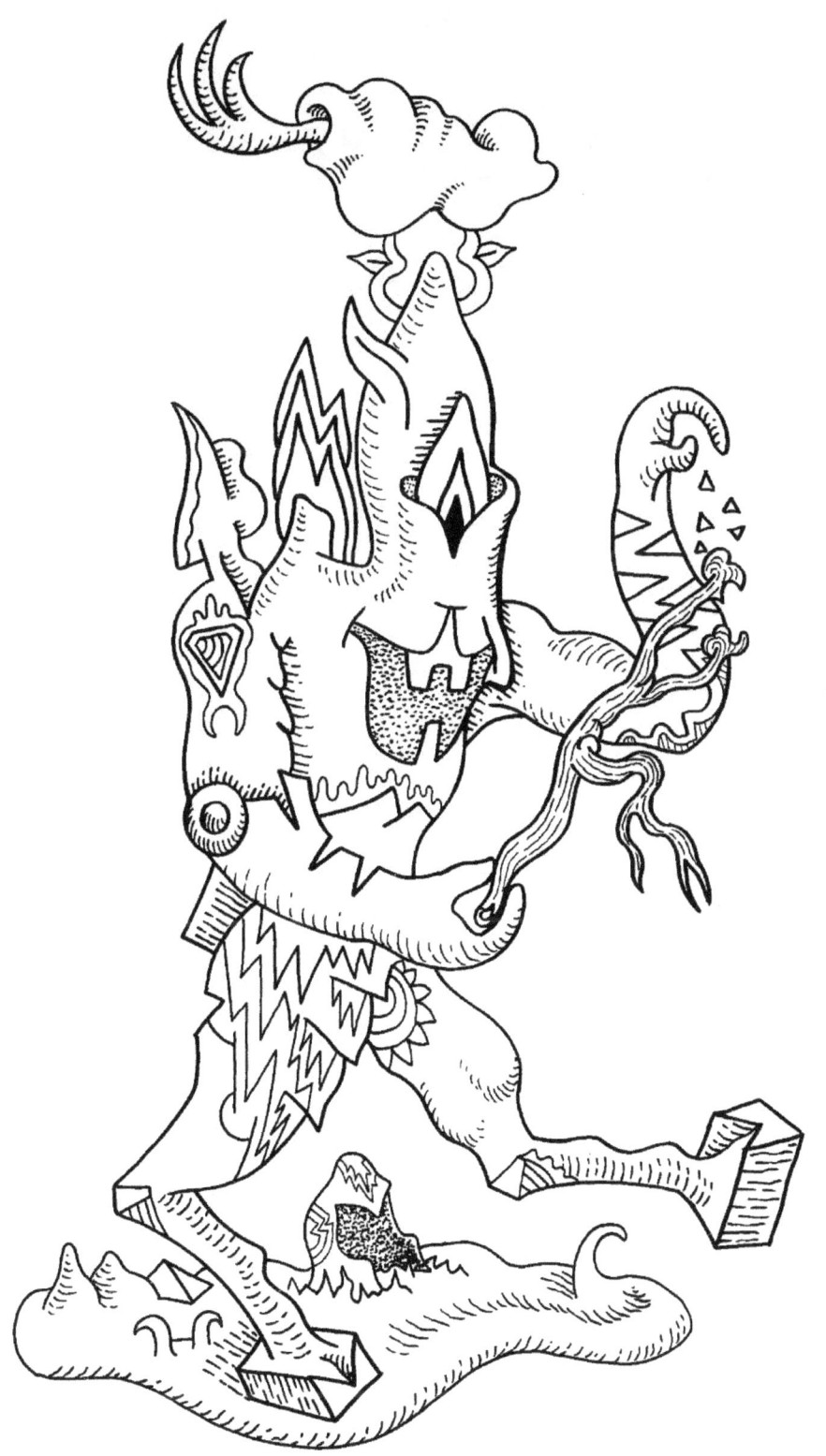

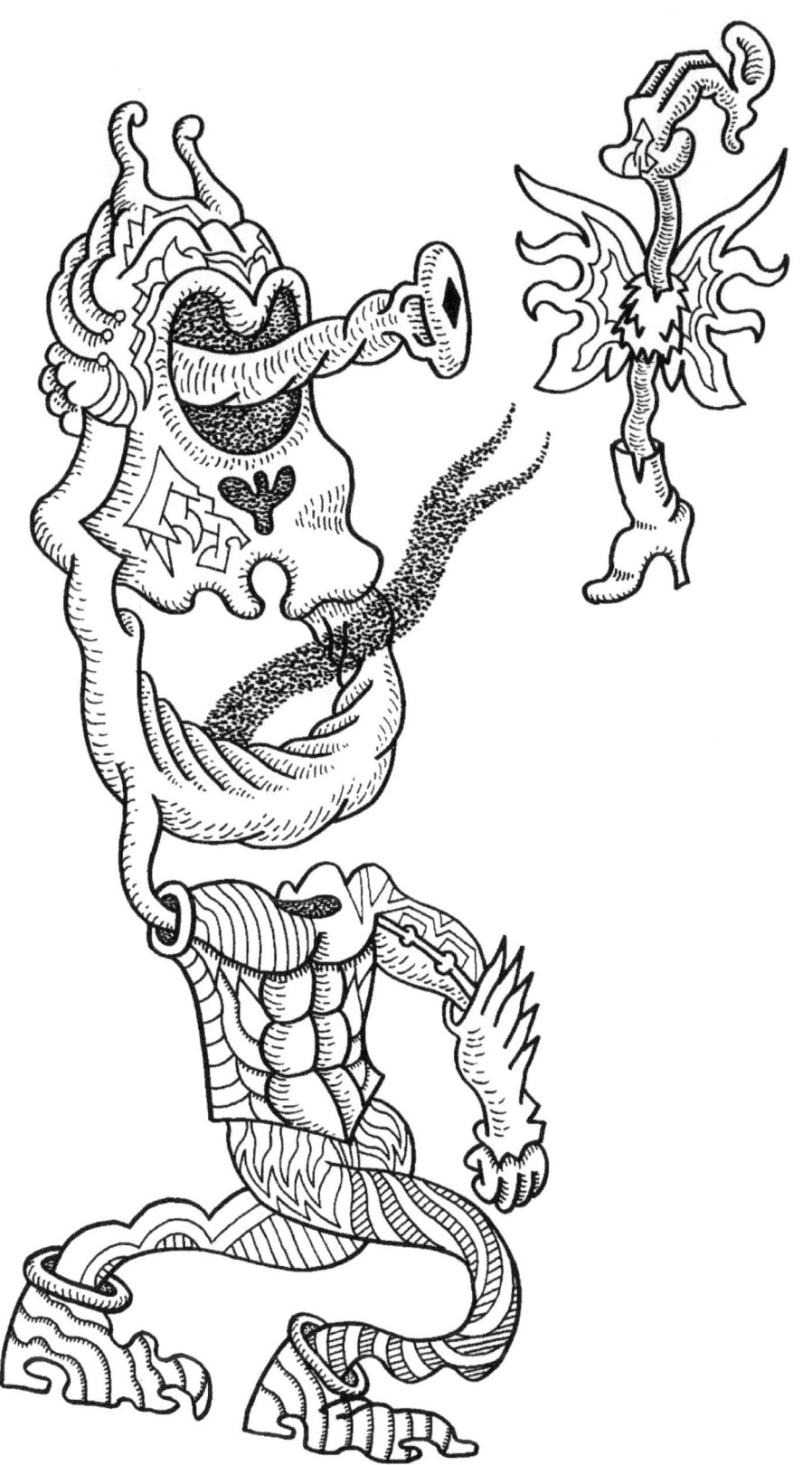

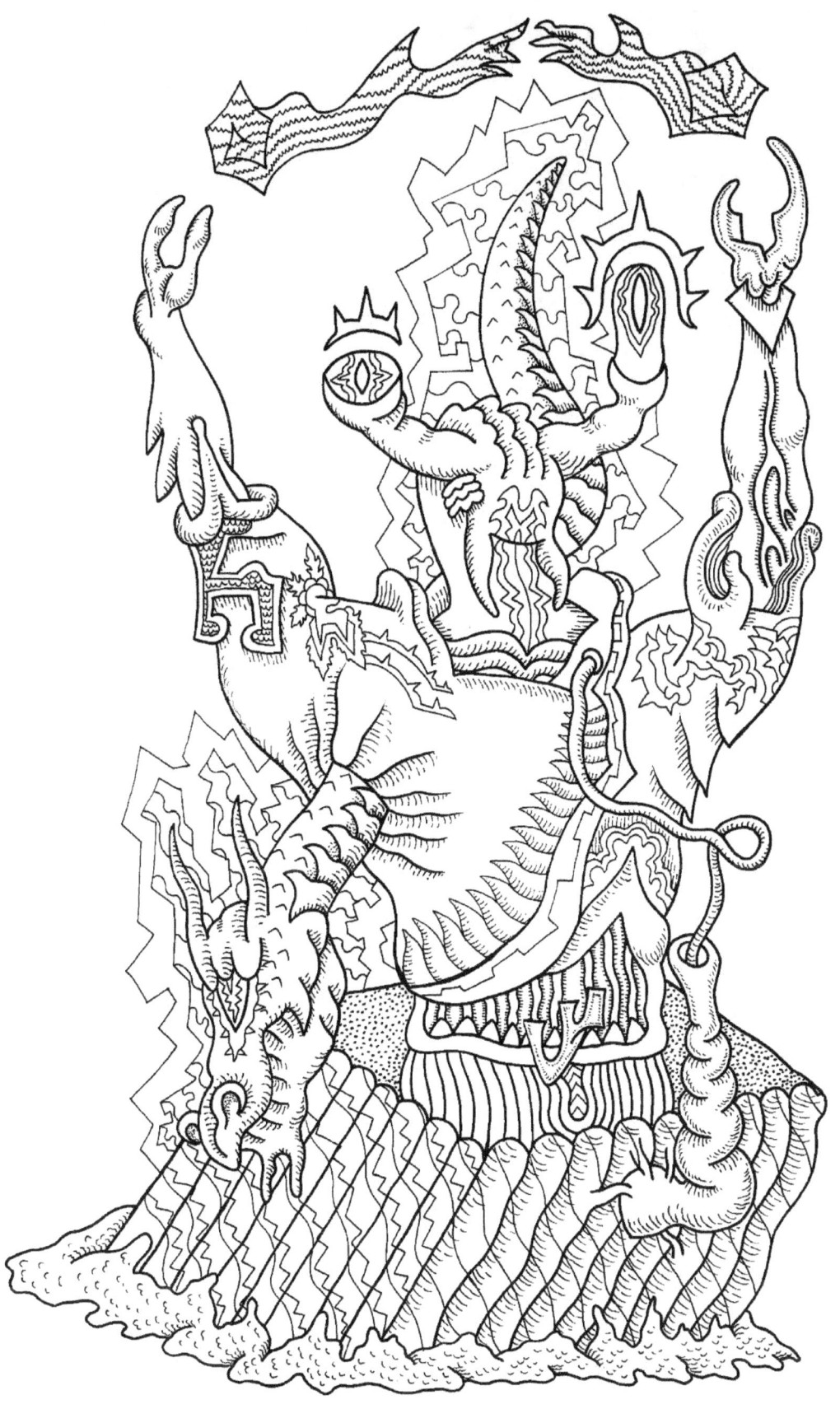

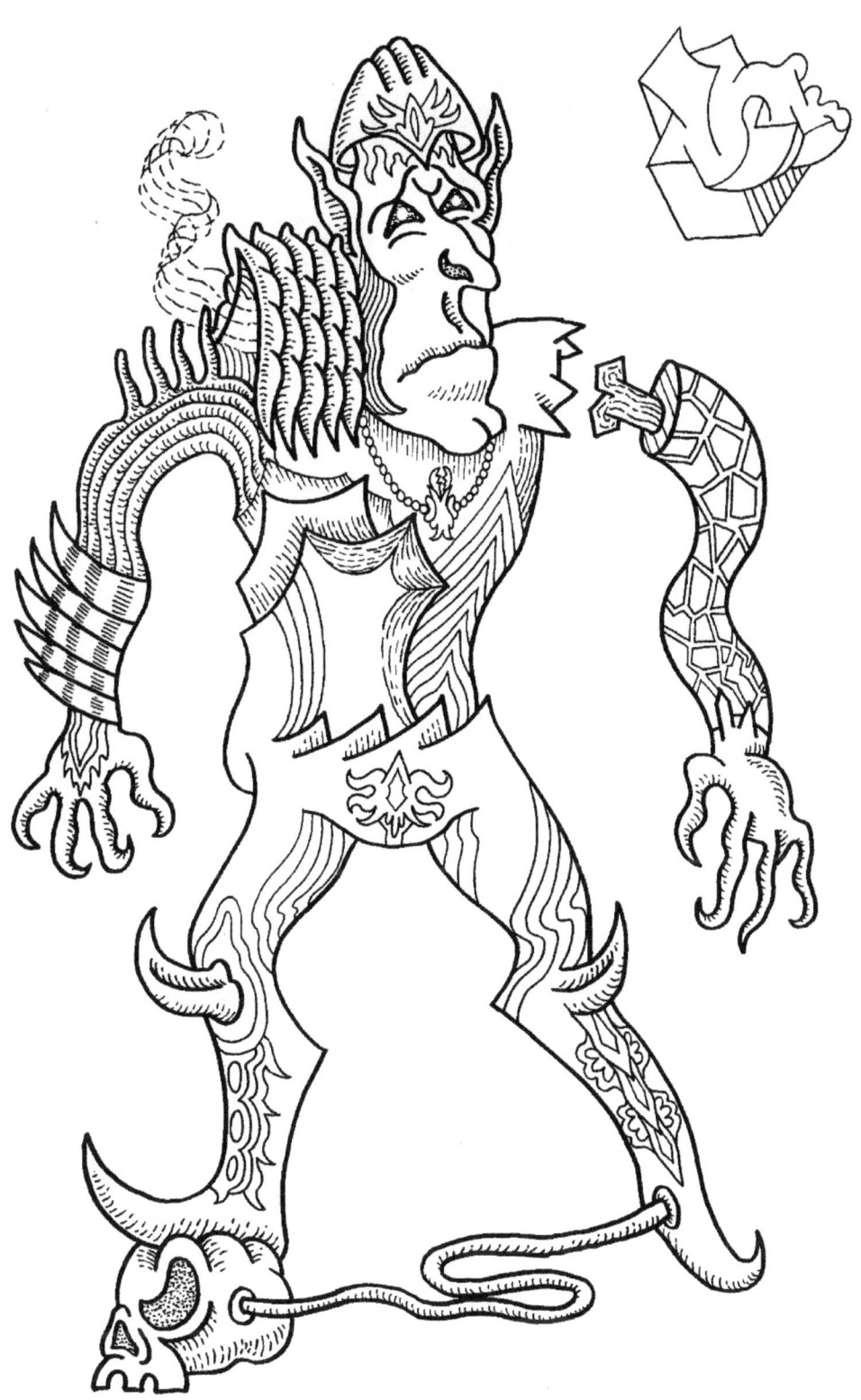

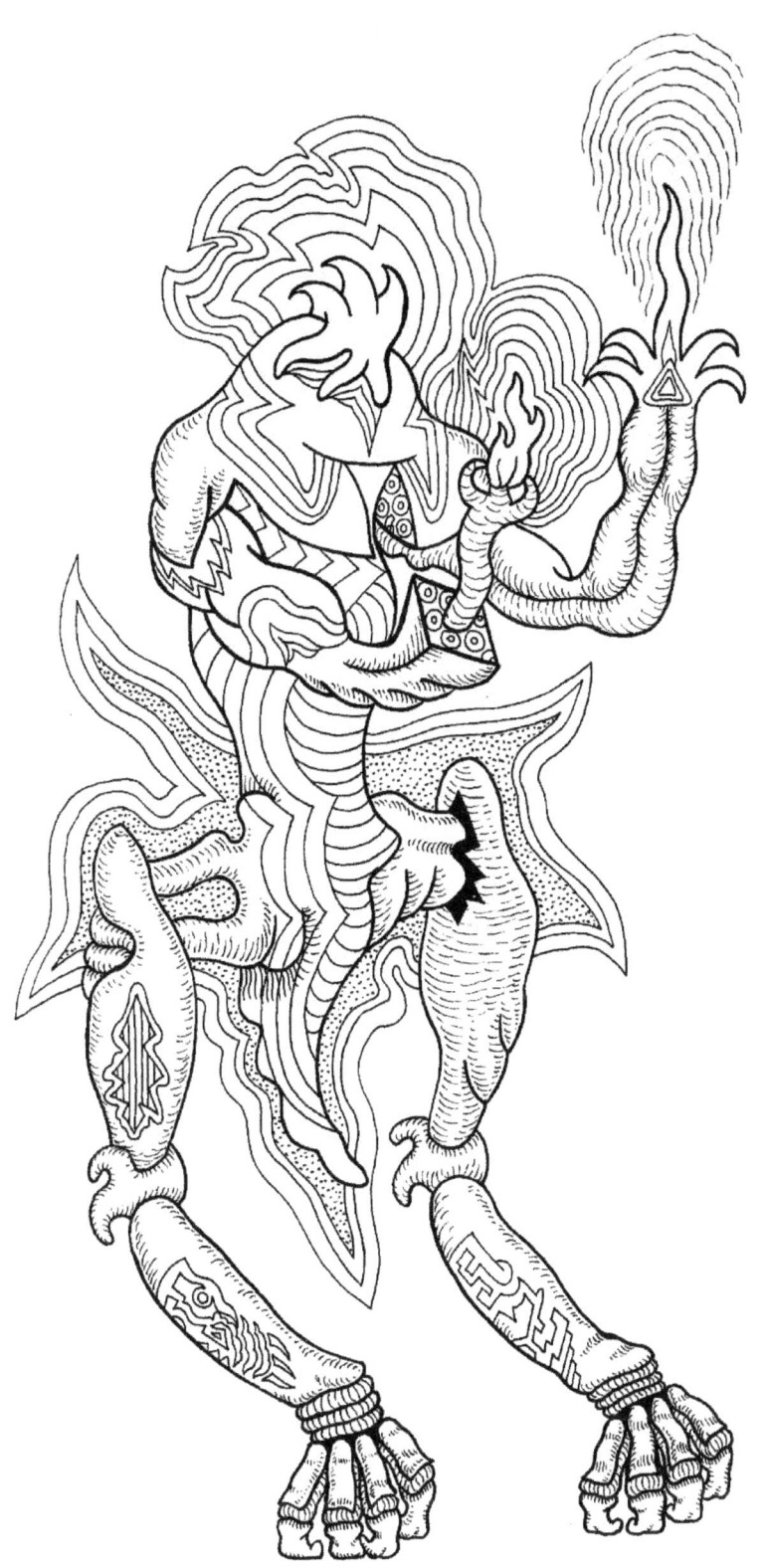

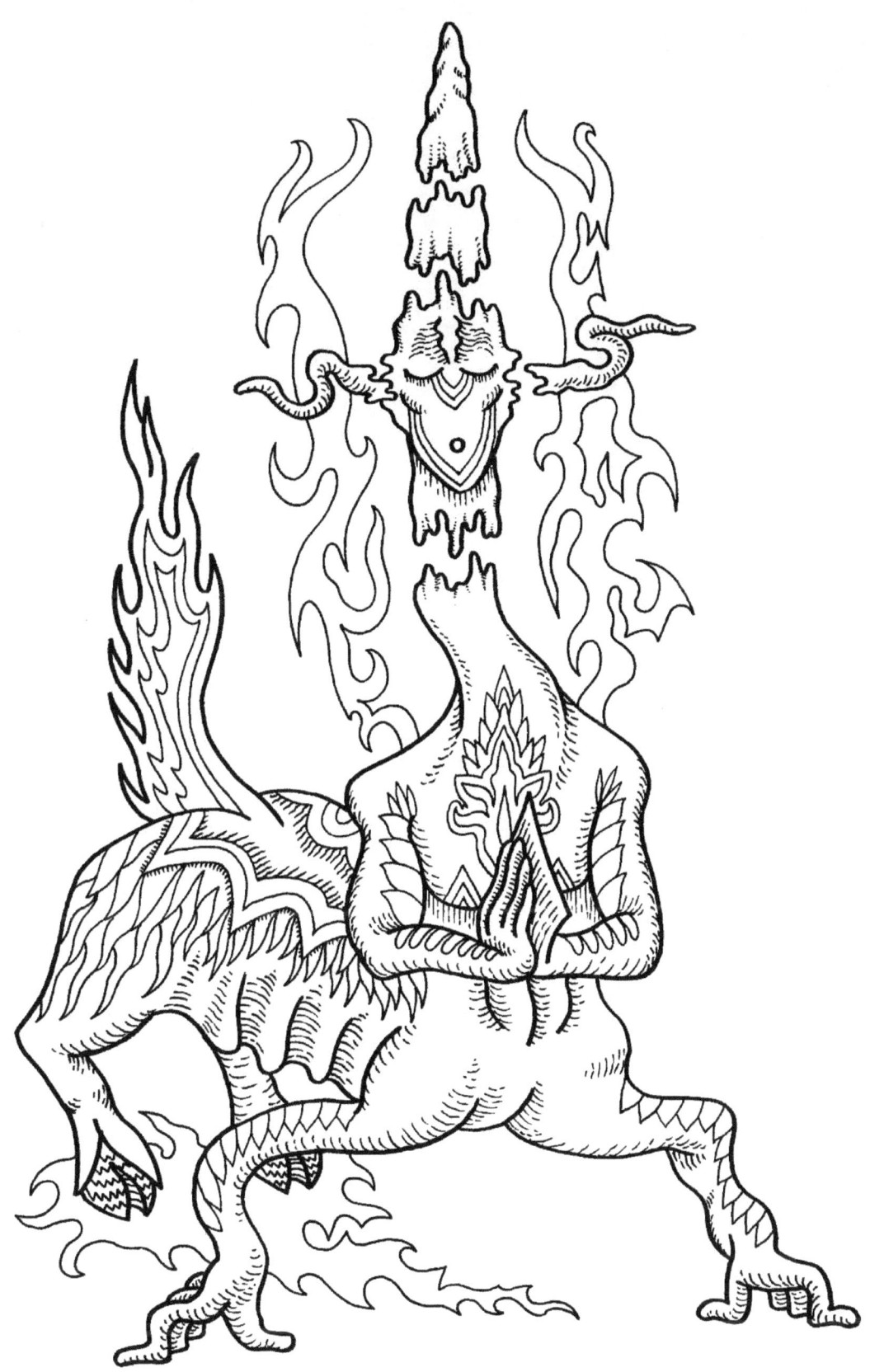

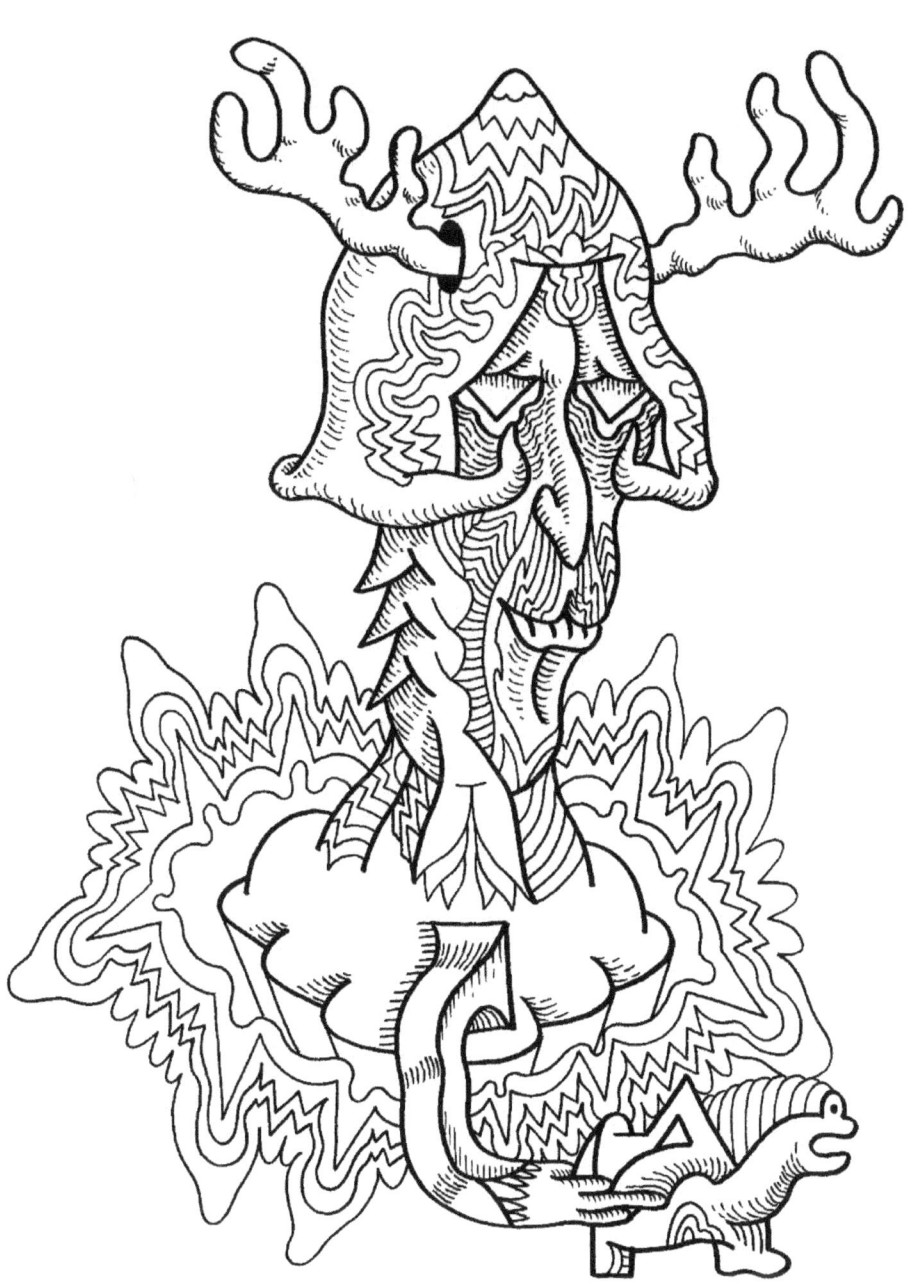

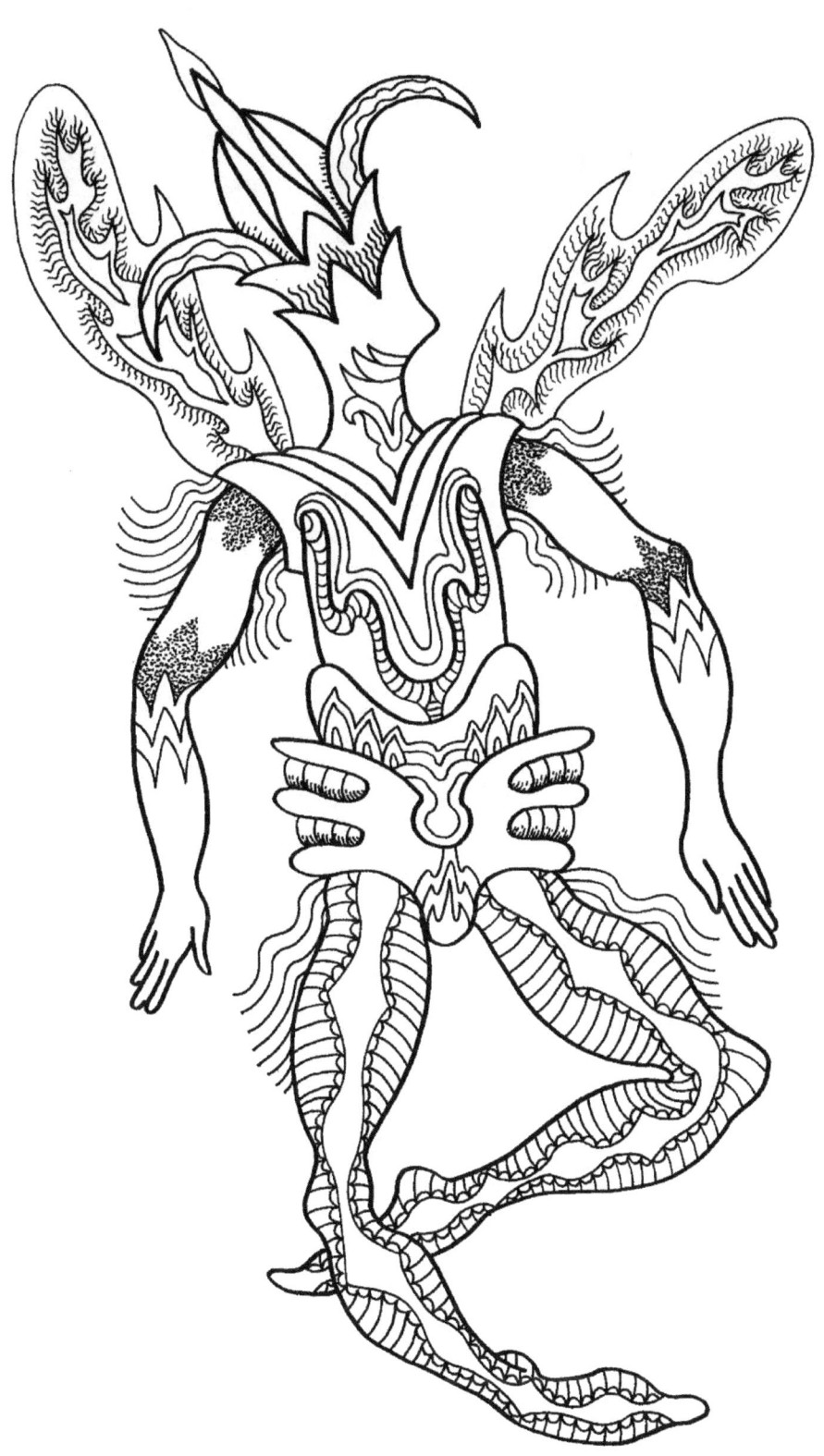

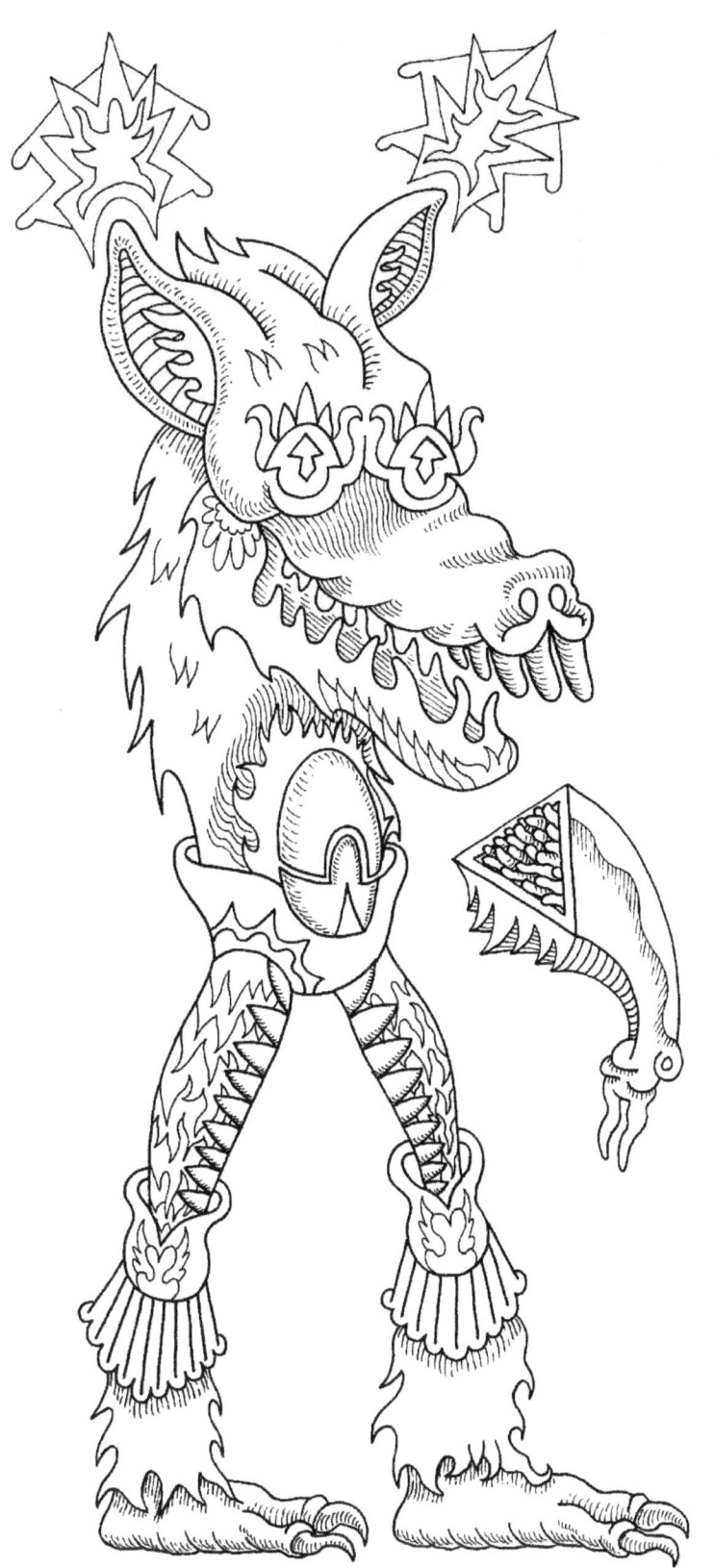

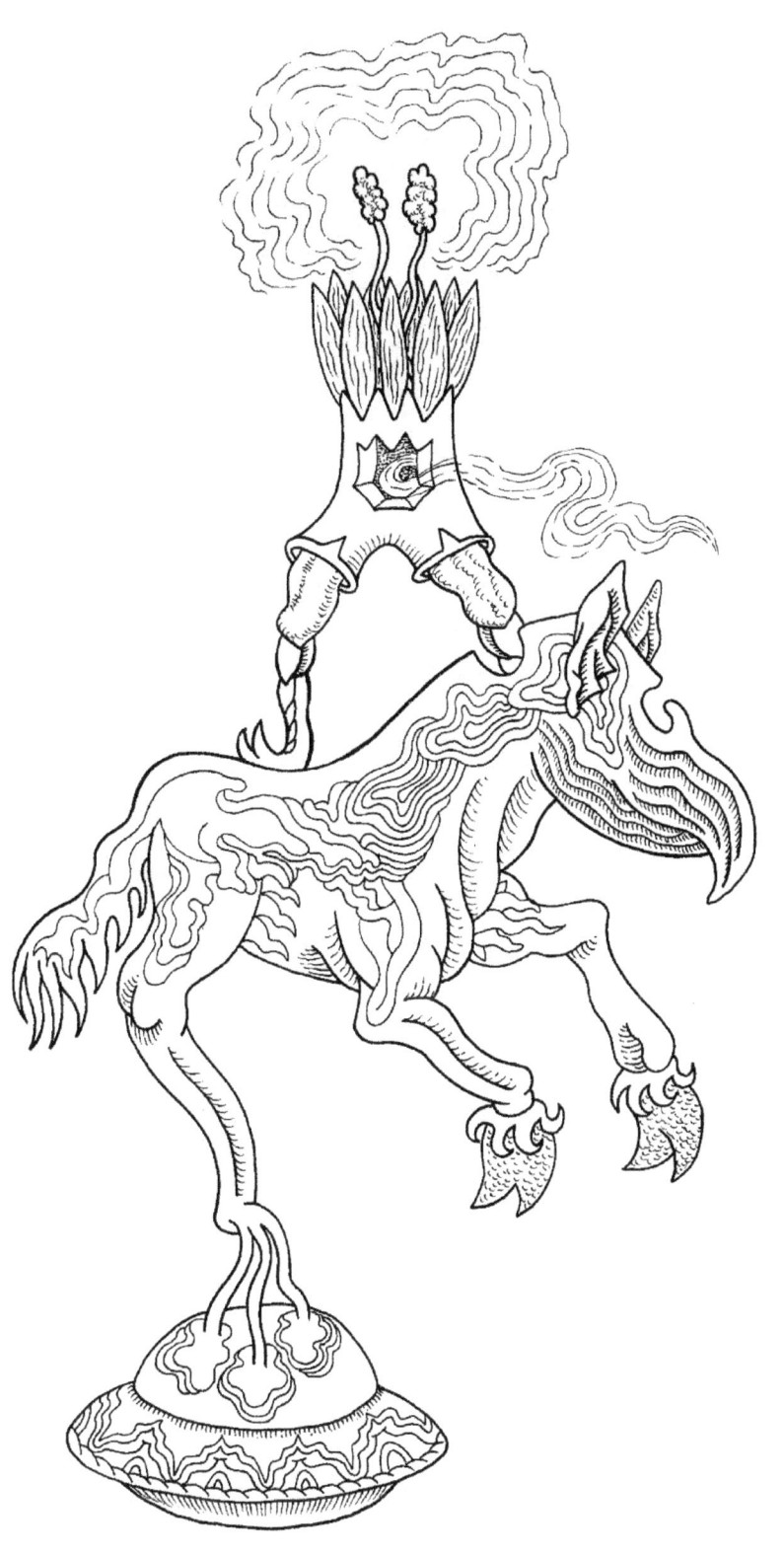

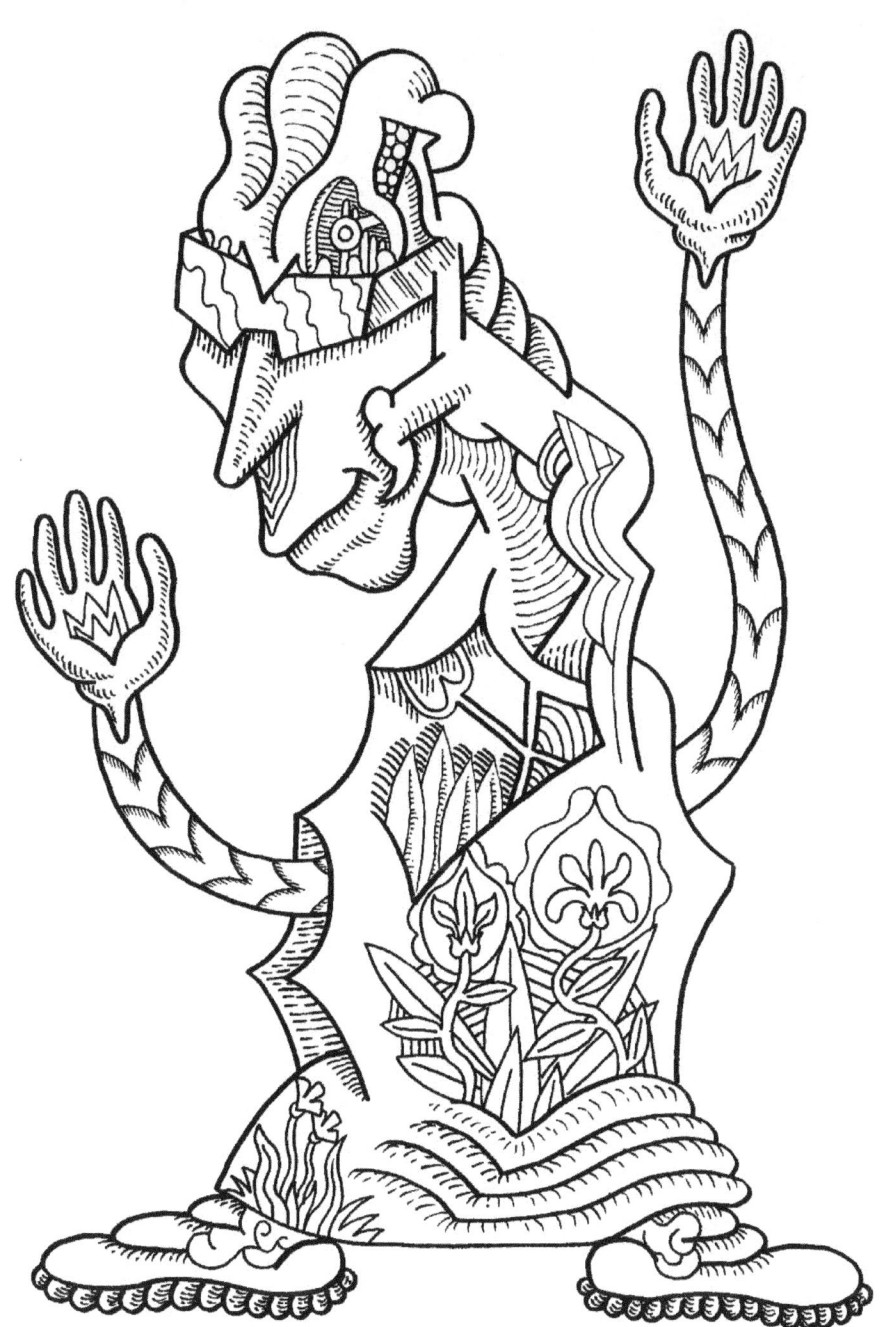

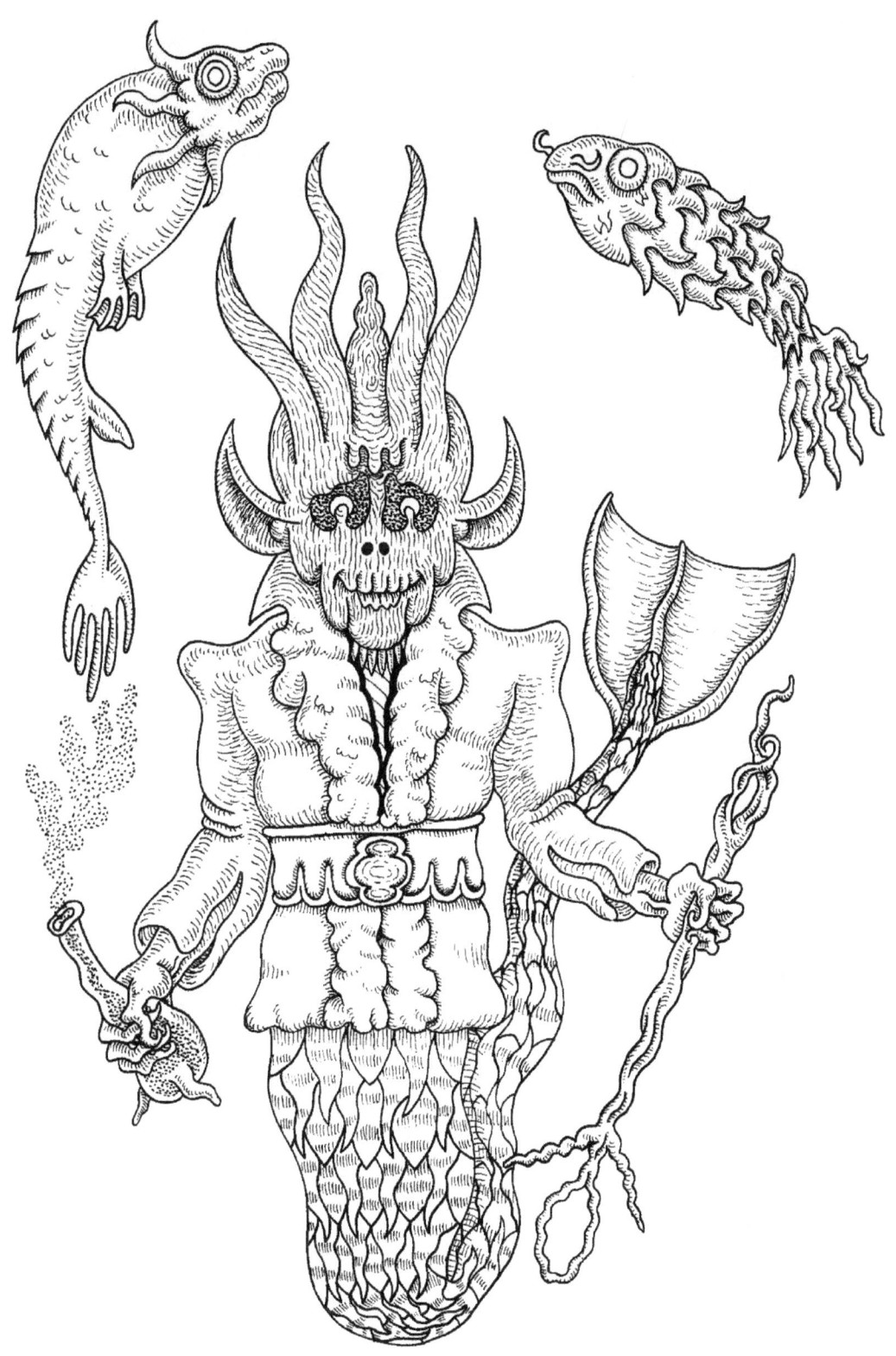

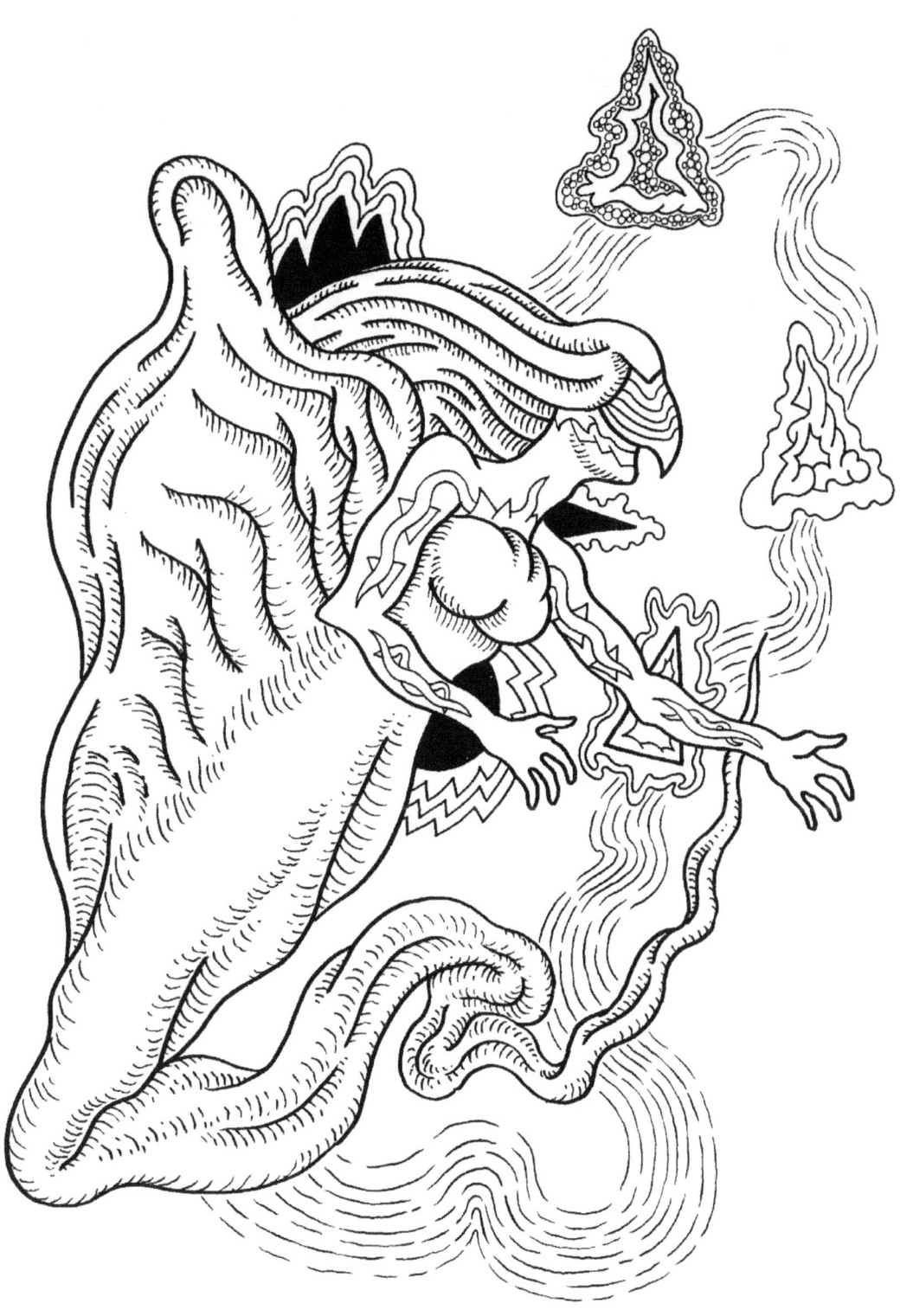

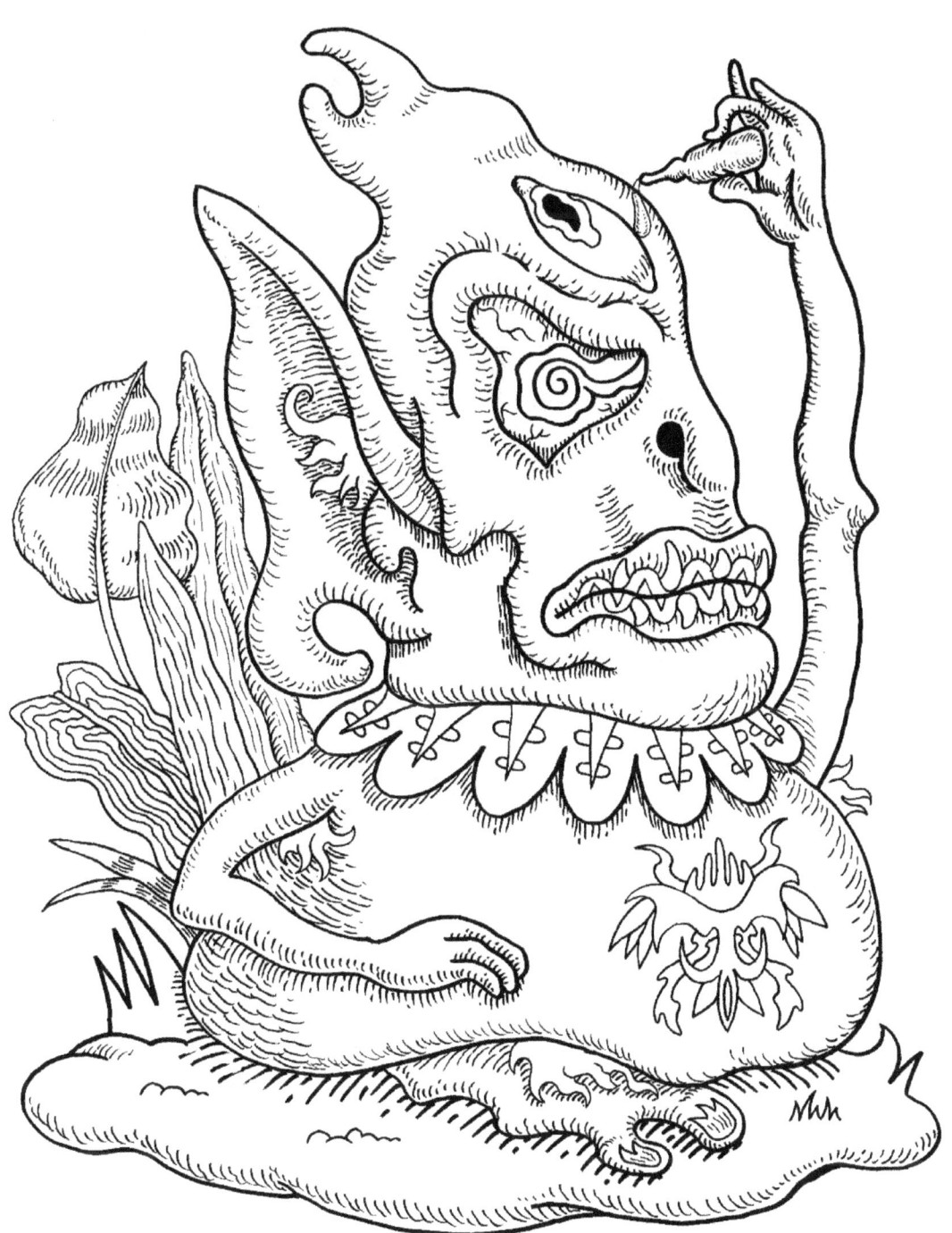

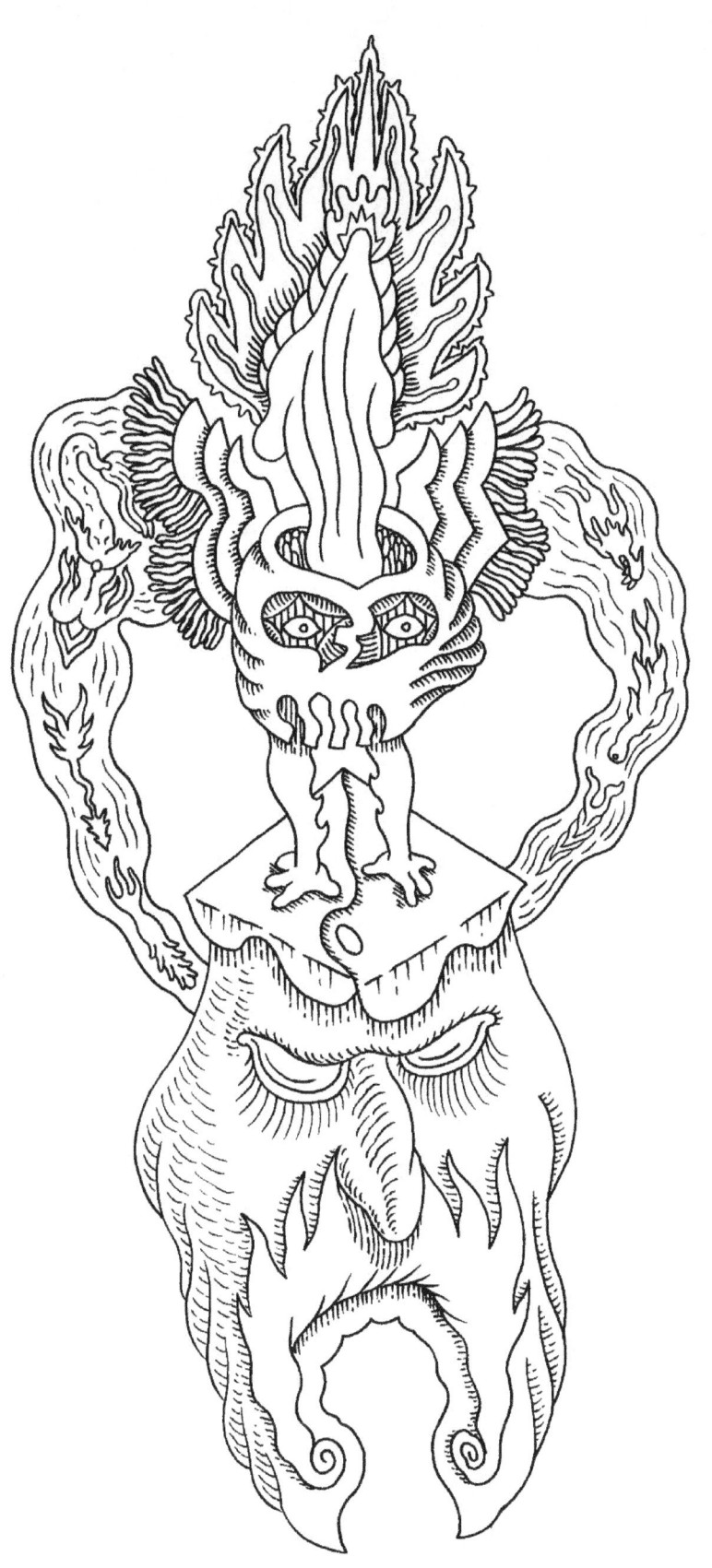

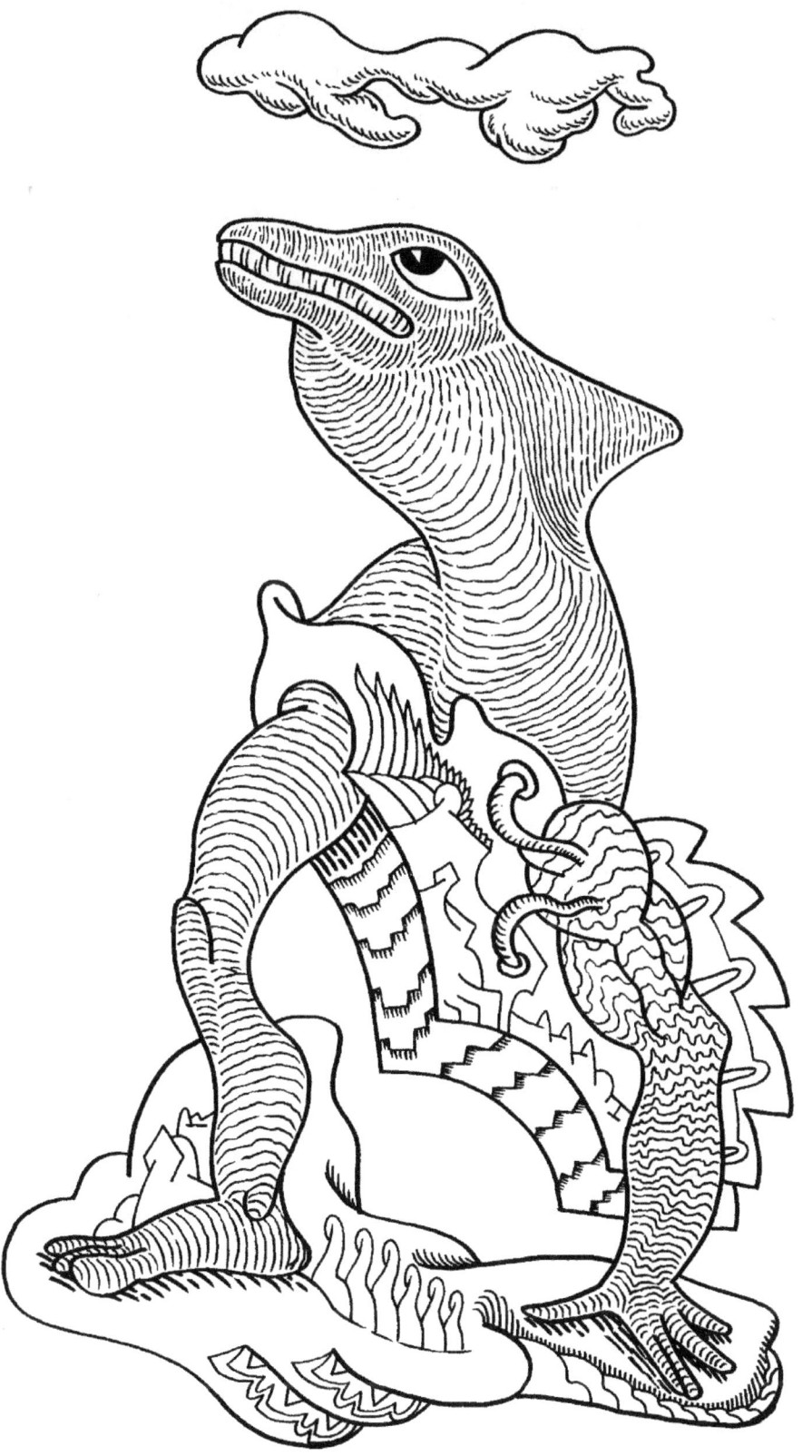

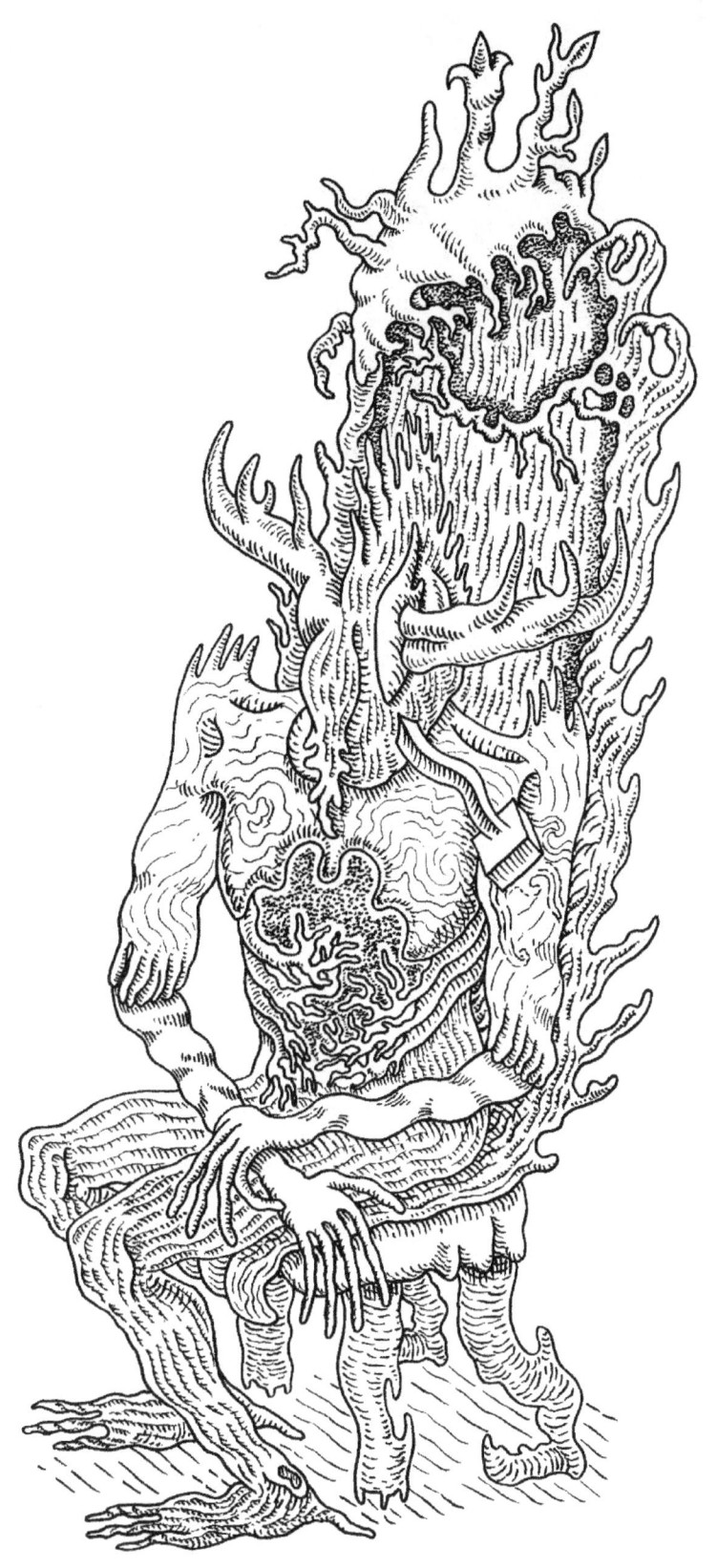

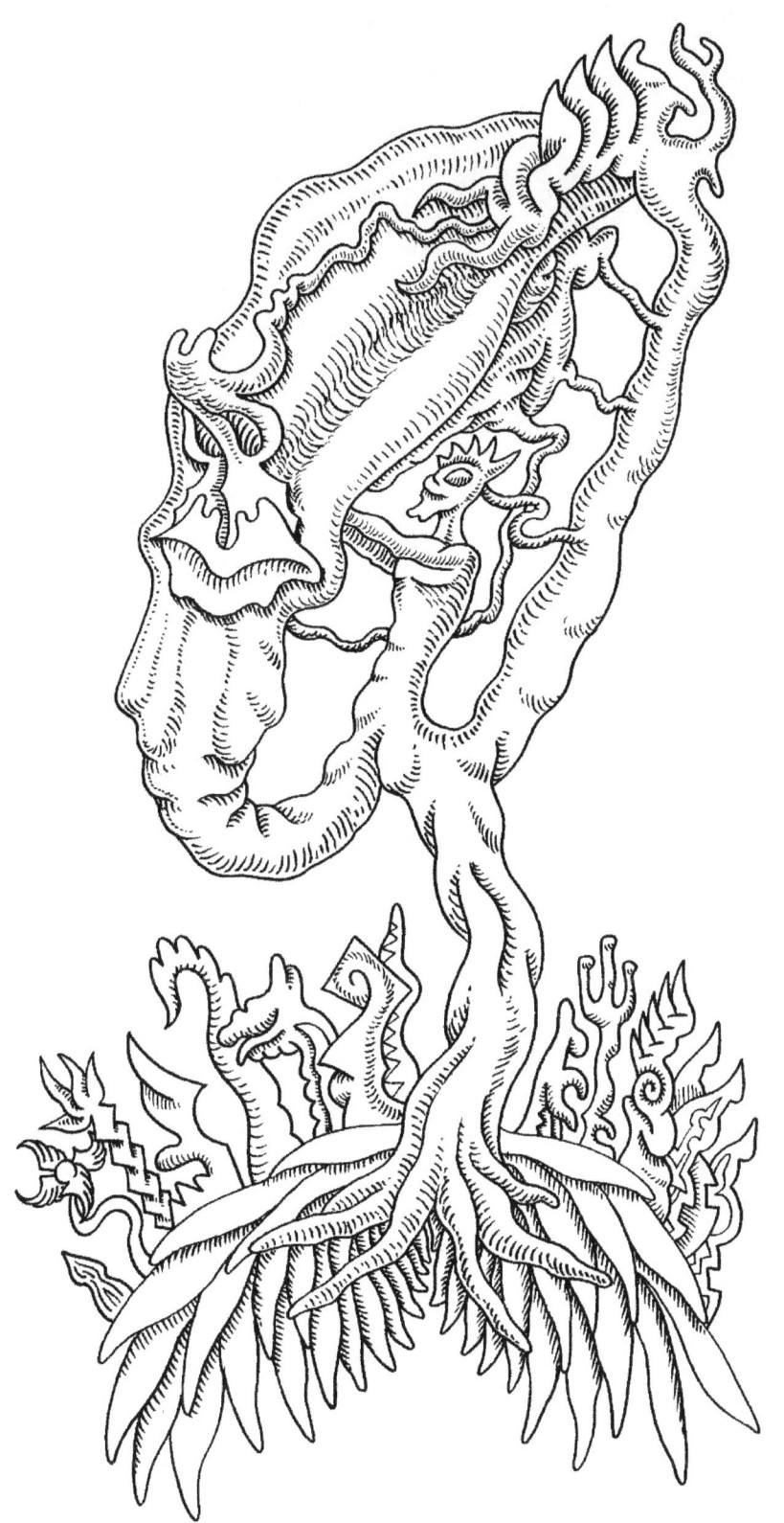

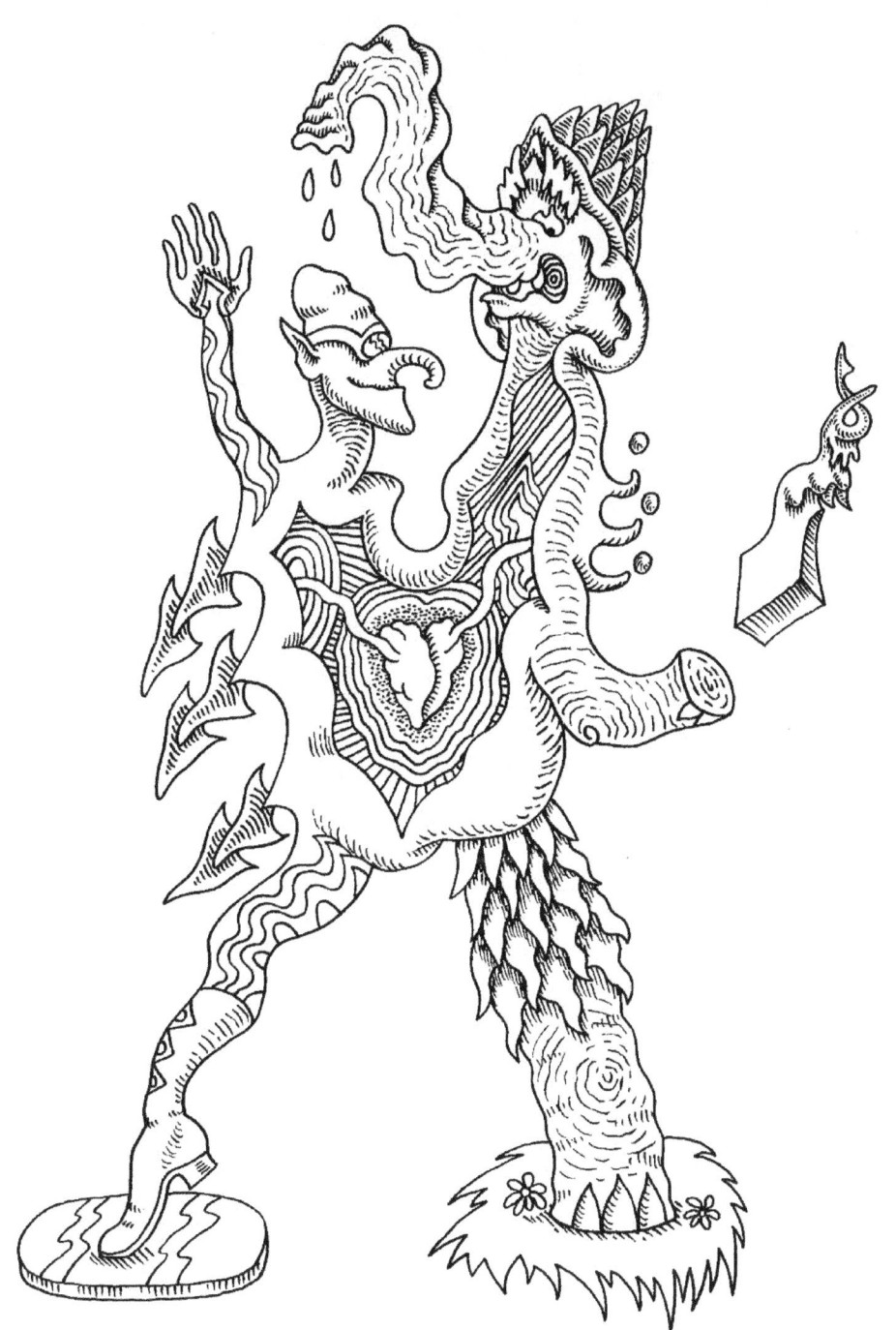

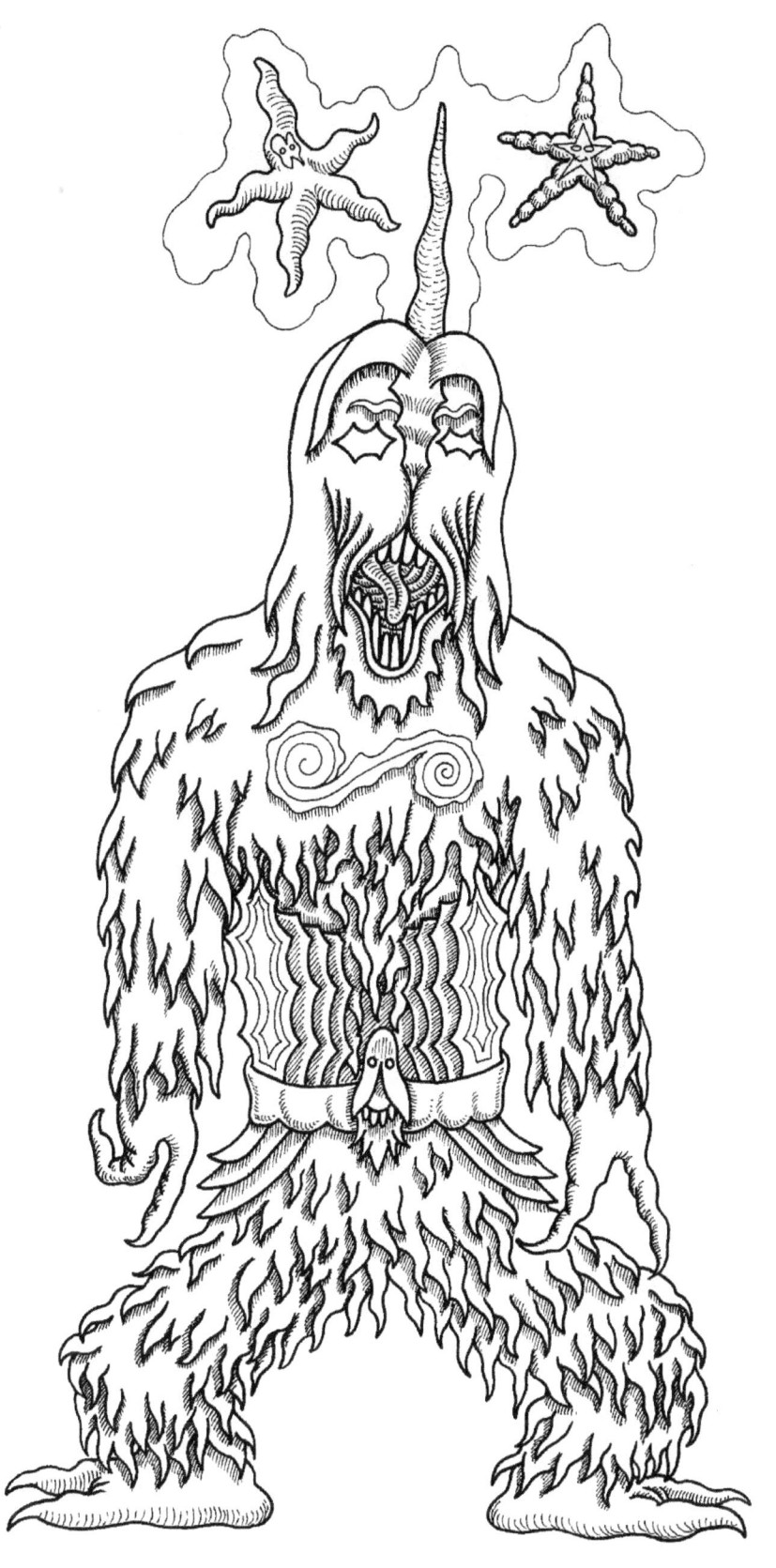

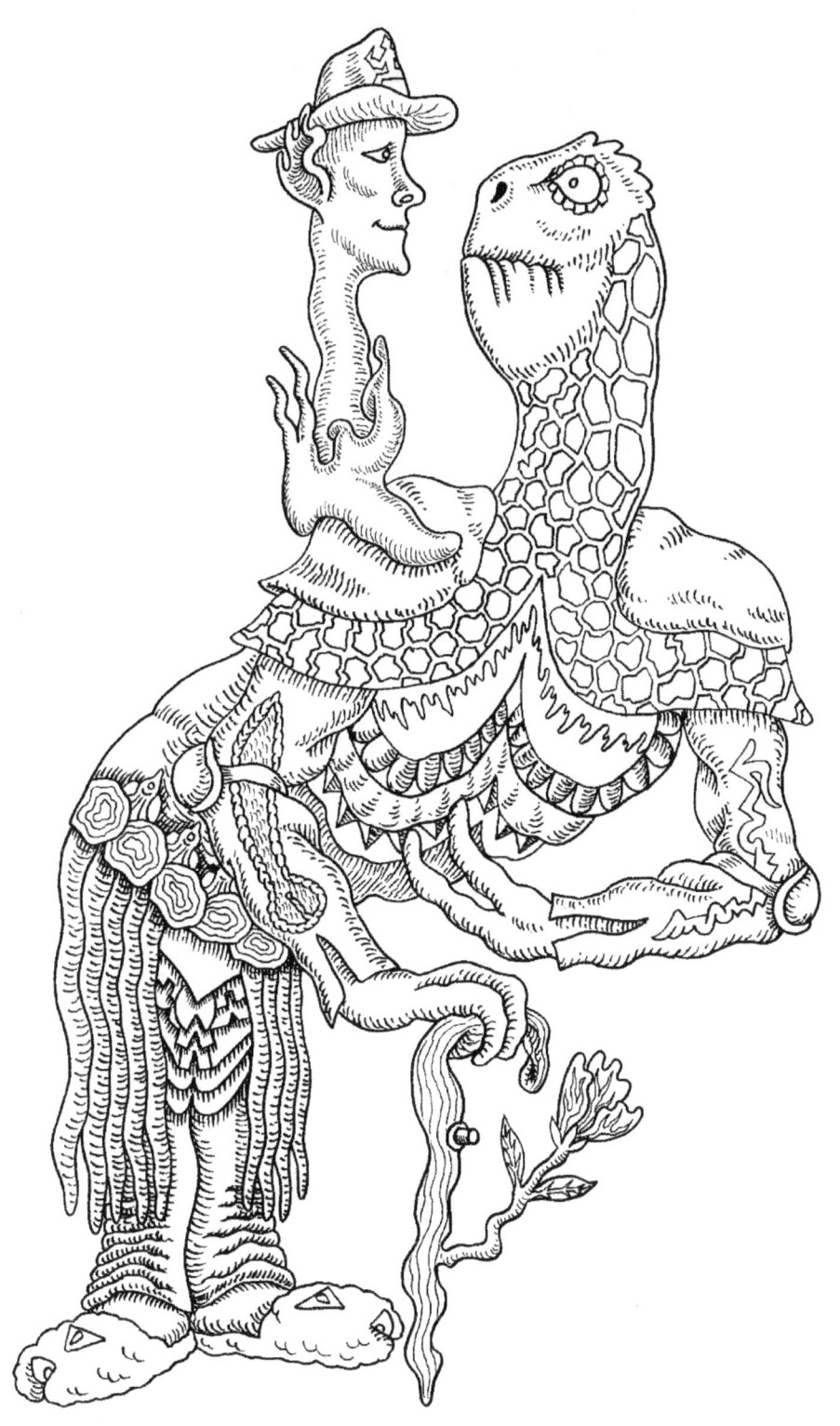

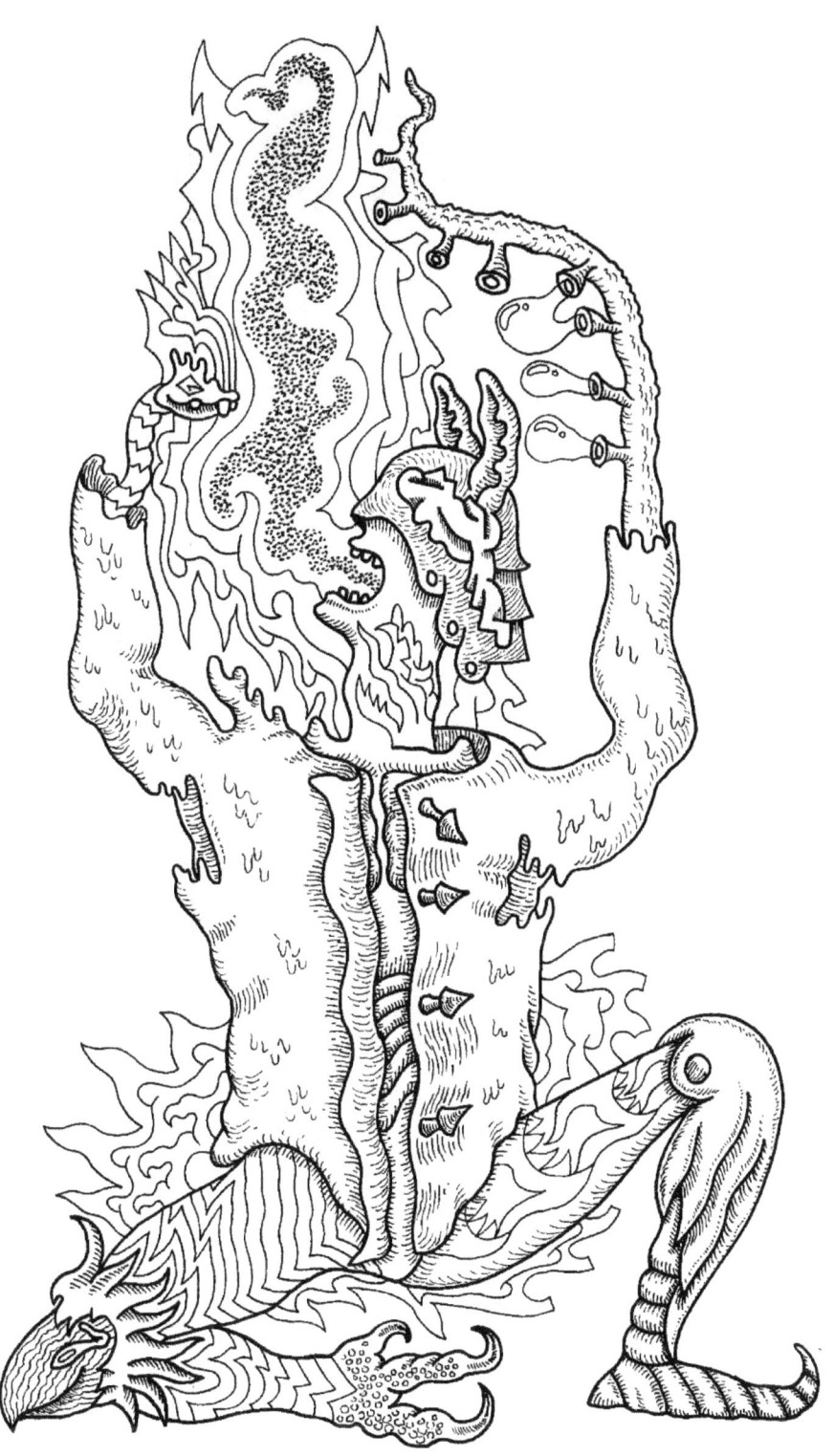

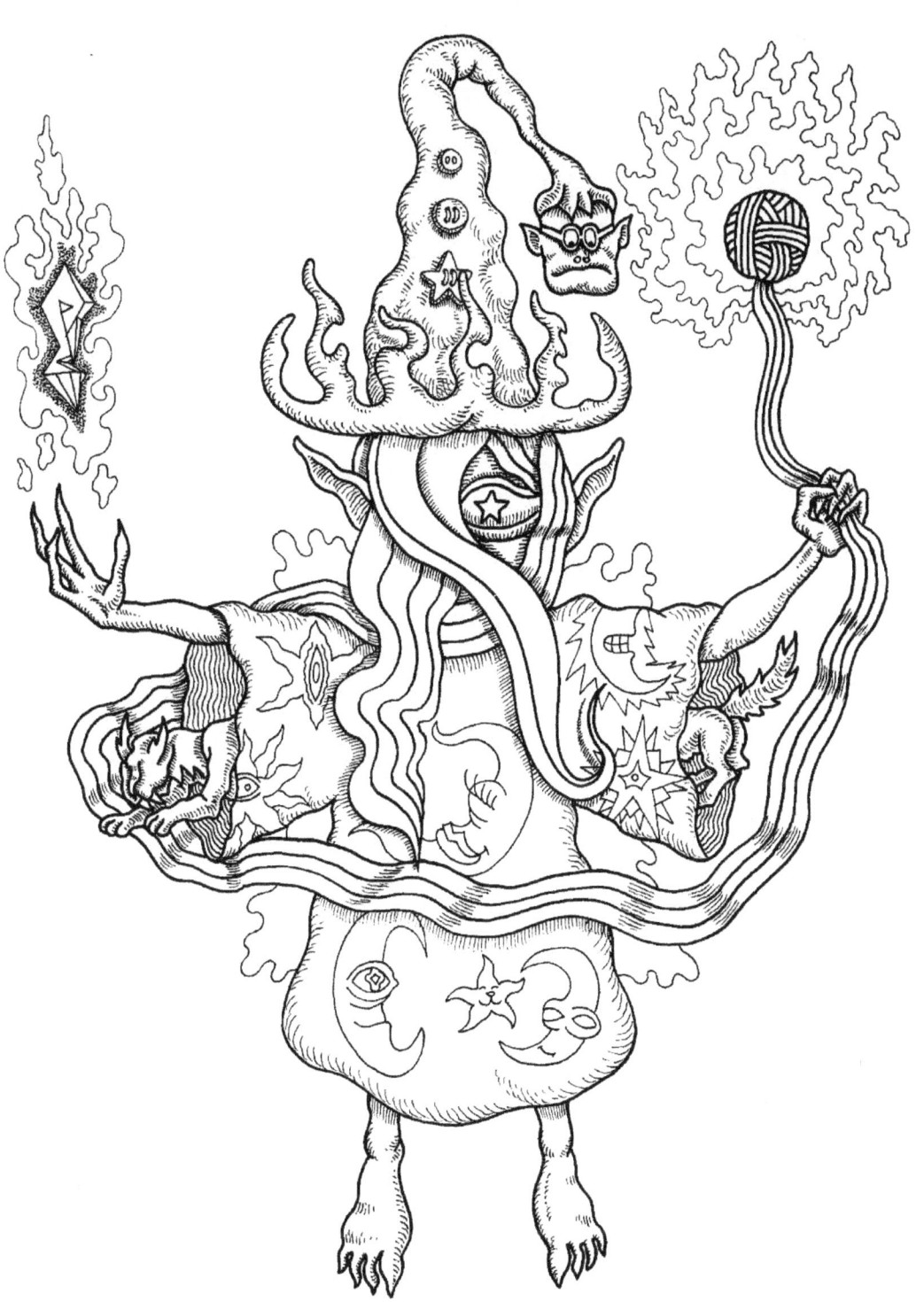

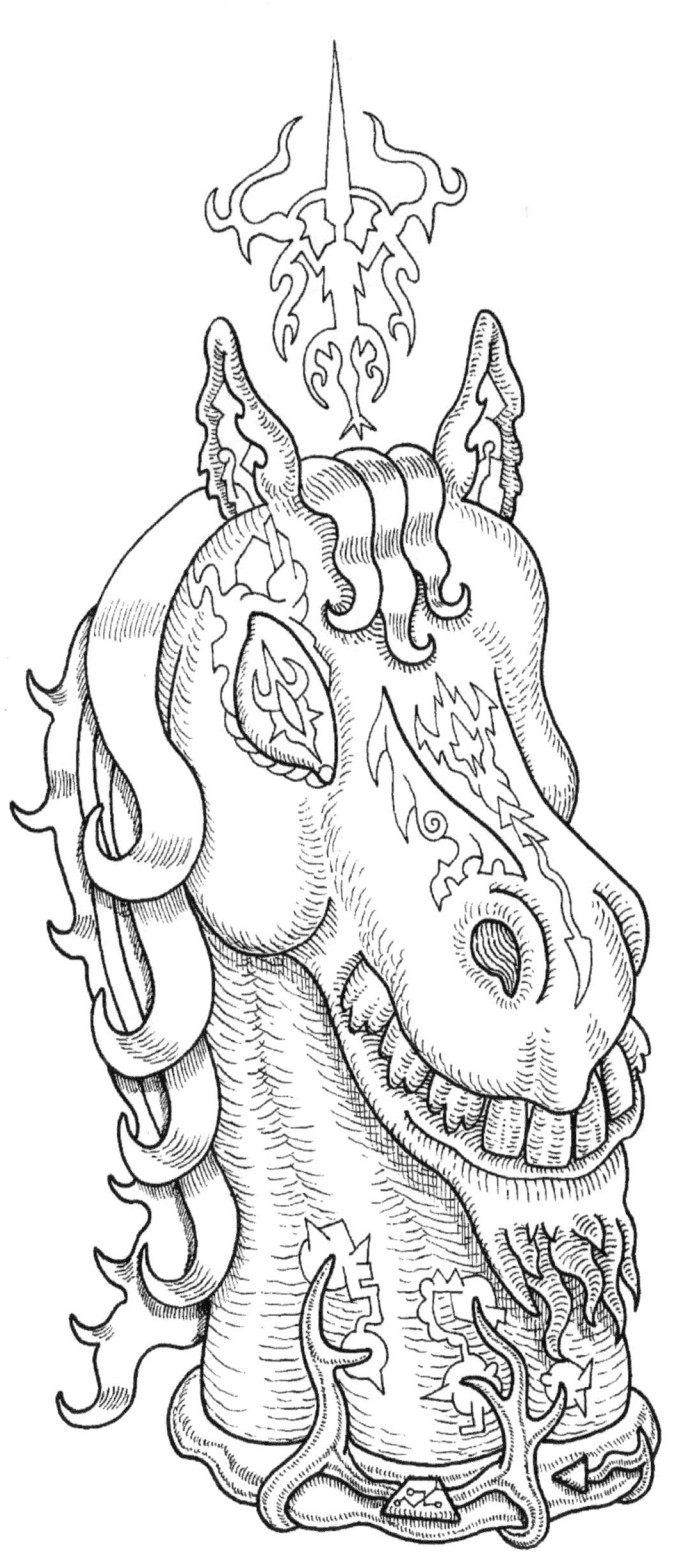

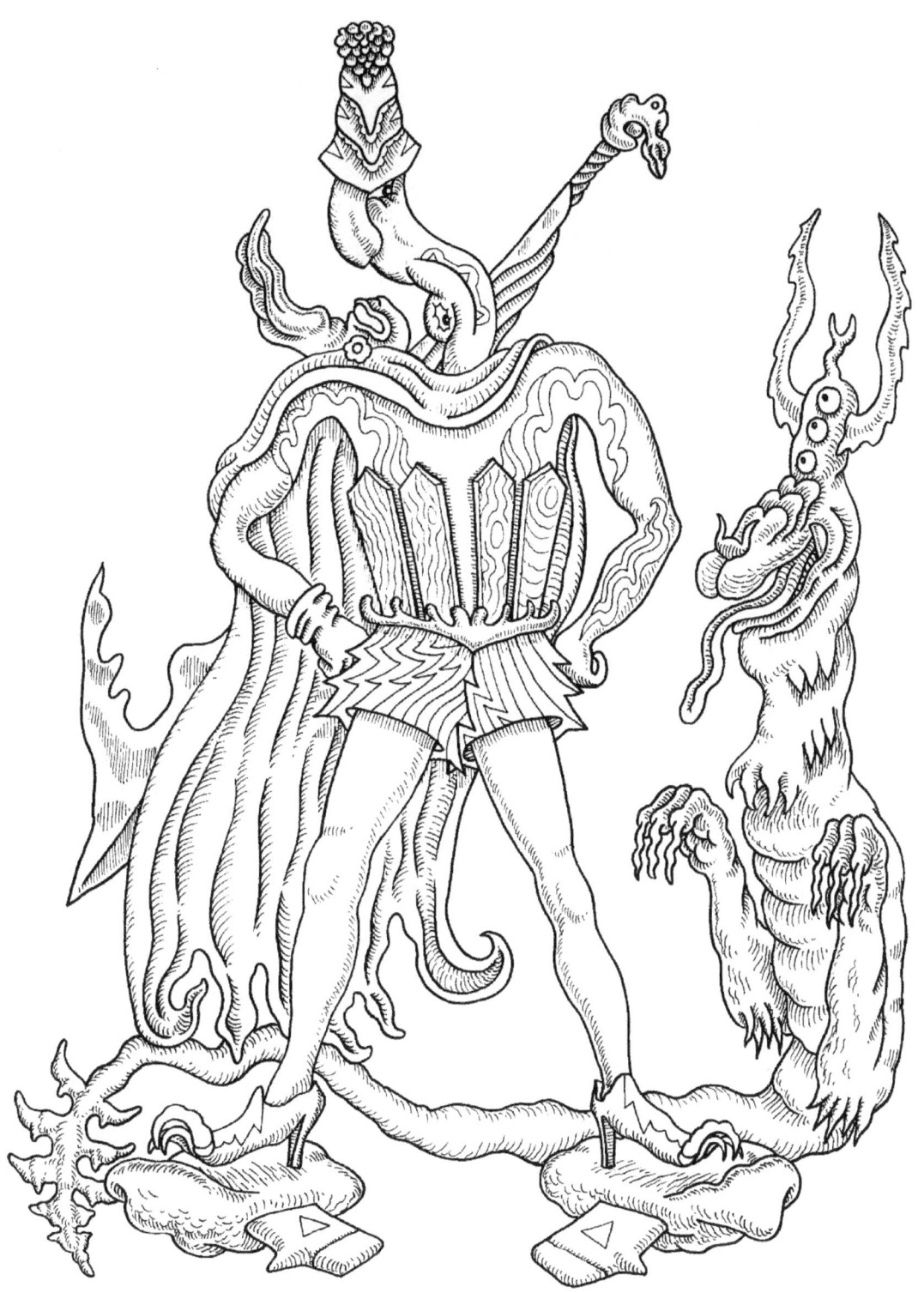

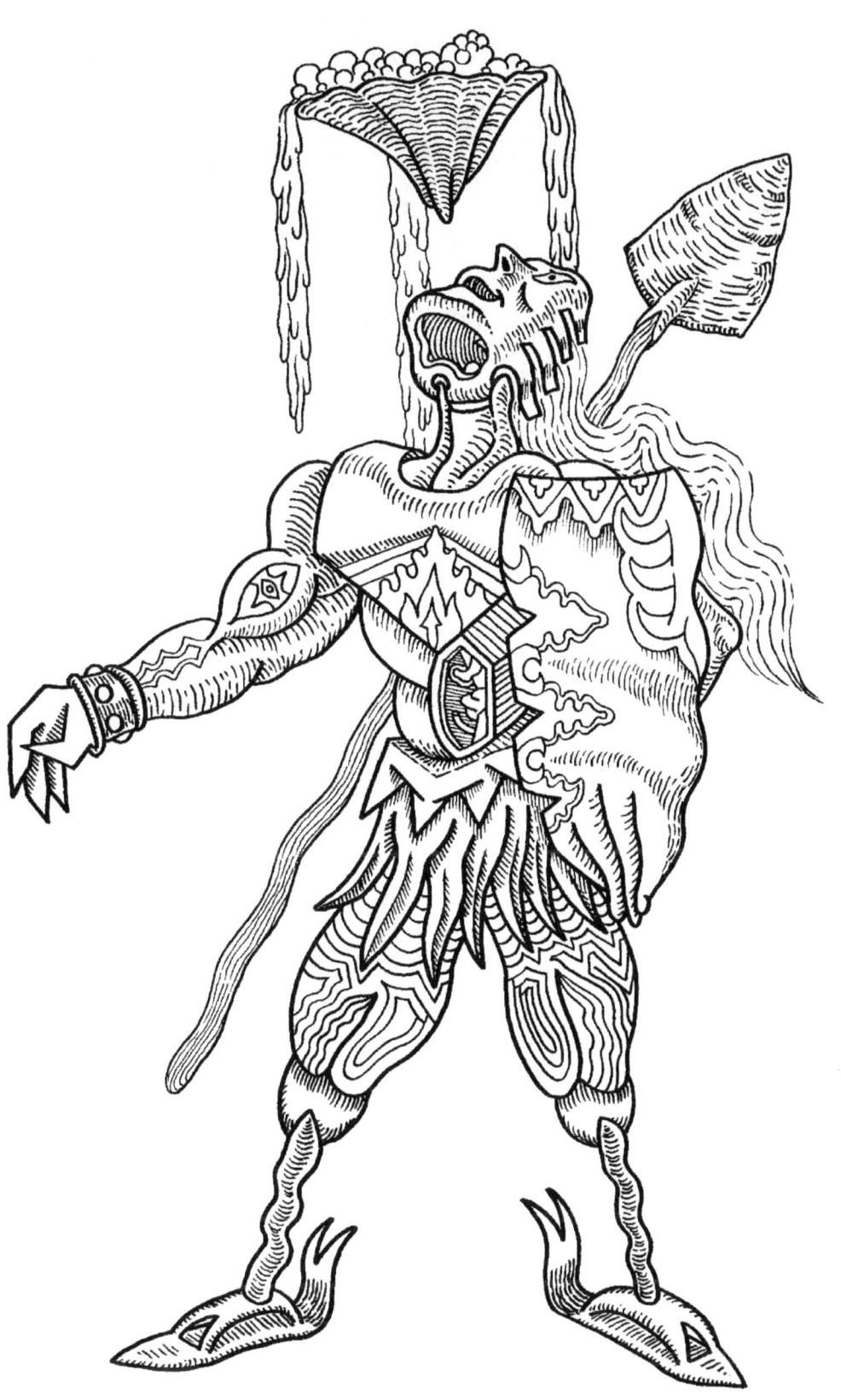

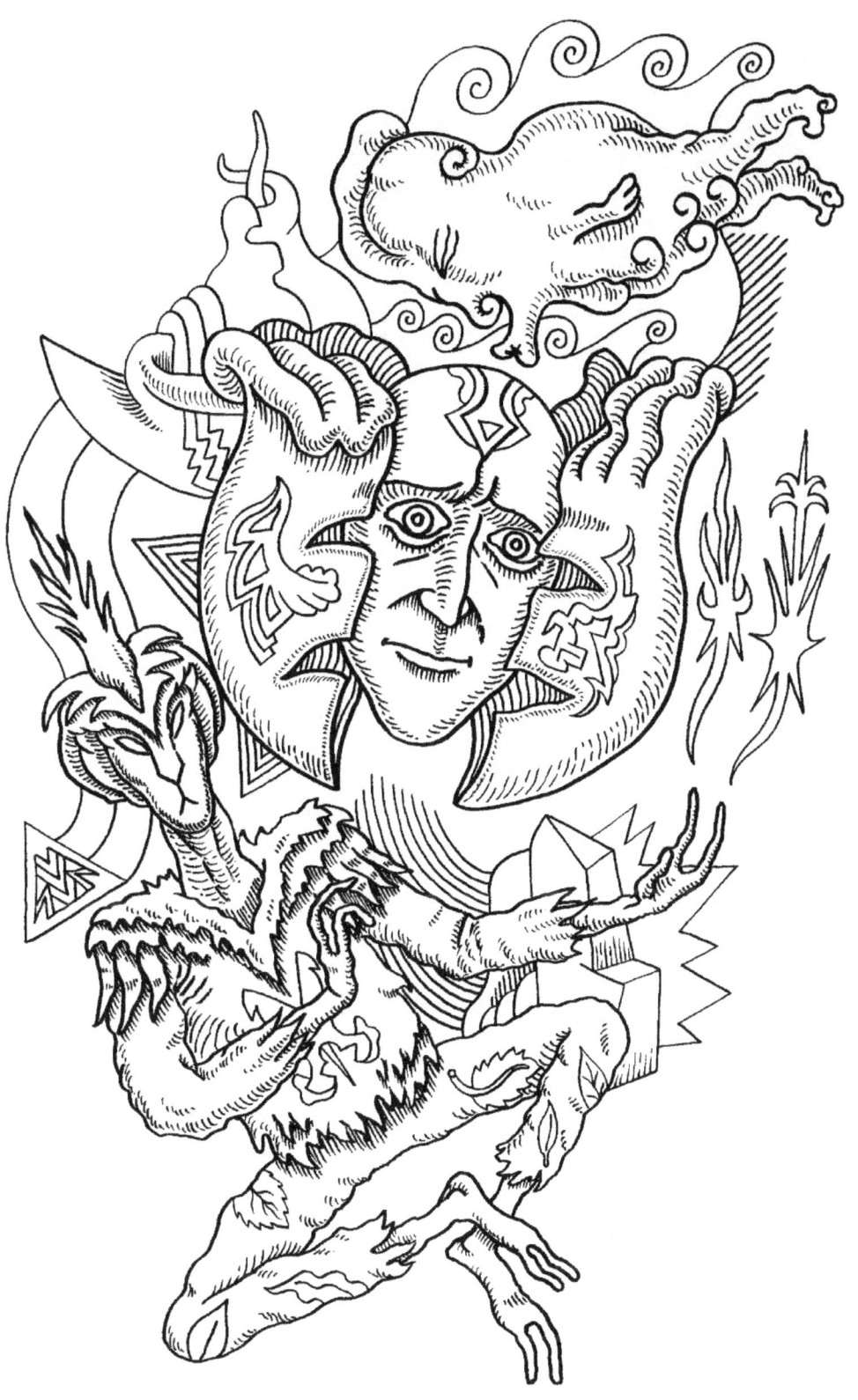

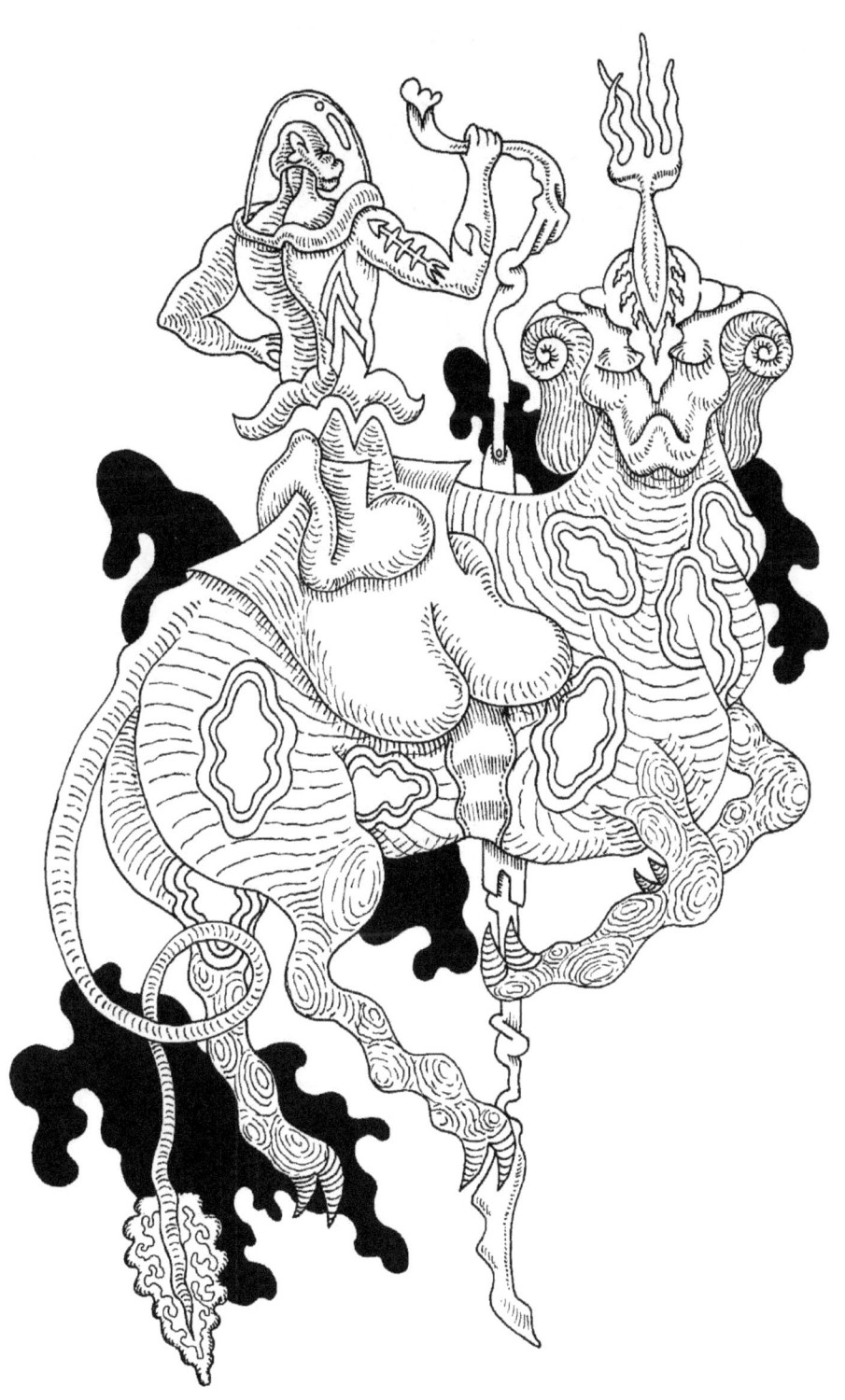

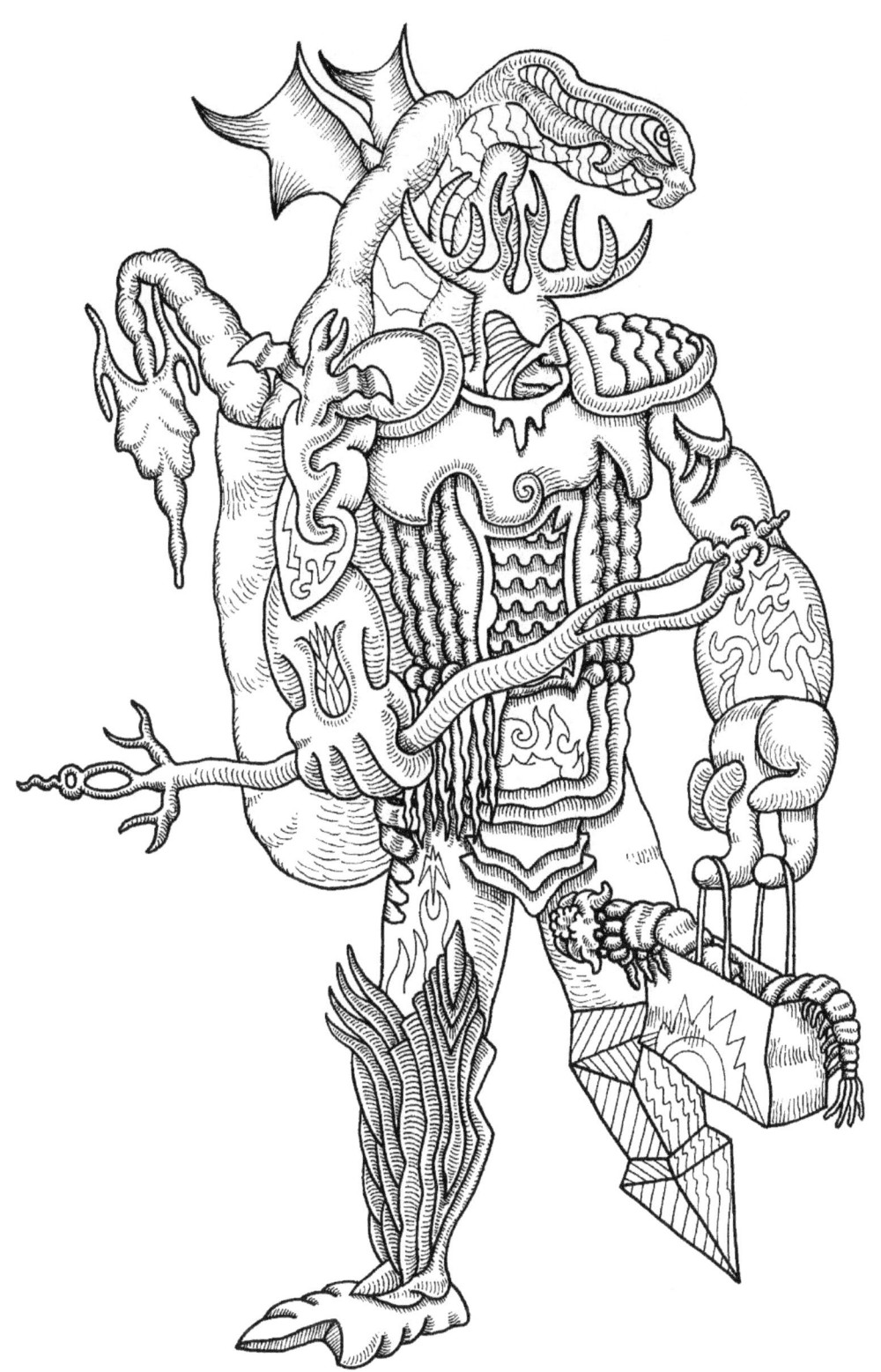